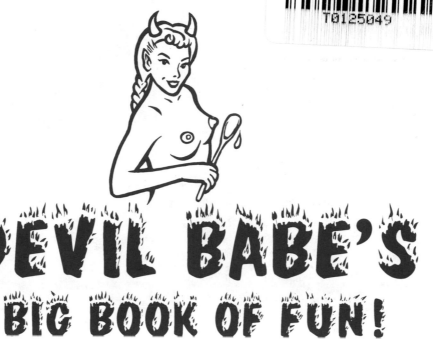

DEVIL BABE'S
BIG BOOK OF FUN!

Isabel Samaras

Manic D Press
San Francisco

TO MARCOS, WHO BRINGS OUT THE DEVIL BABE IN ME.

The author offers wads of gratitude to the devilish test chefs Jayel, Jenny S., Steve Z., Mom, Shannon B., Carol S., and Jen (not only an editor but a mean baker!), maze-master Marcos and all the puzzle guinea pigs, Margaret & Isabelle of seeing words design, Michael's helping hands, the support of my Demon Sisters, and to all the women and men (real and imagined) who inspired this book.

ISBN 0-916397-52-1

To learn more about Devil Babe and Isabel Samaras, check out: www.astrocat.com/samaras/devilbabe.

For a price list and current catalog of Isabel Samaras's signed original artwork (including limited edition prints of the work in this book) send a SASE to:
Rubber Claw Studios
3288 21st Street #175
San Francisco CA 94110

Distributed to the trade by Publishers Group West

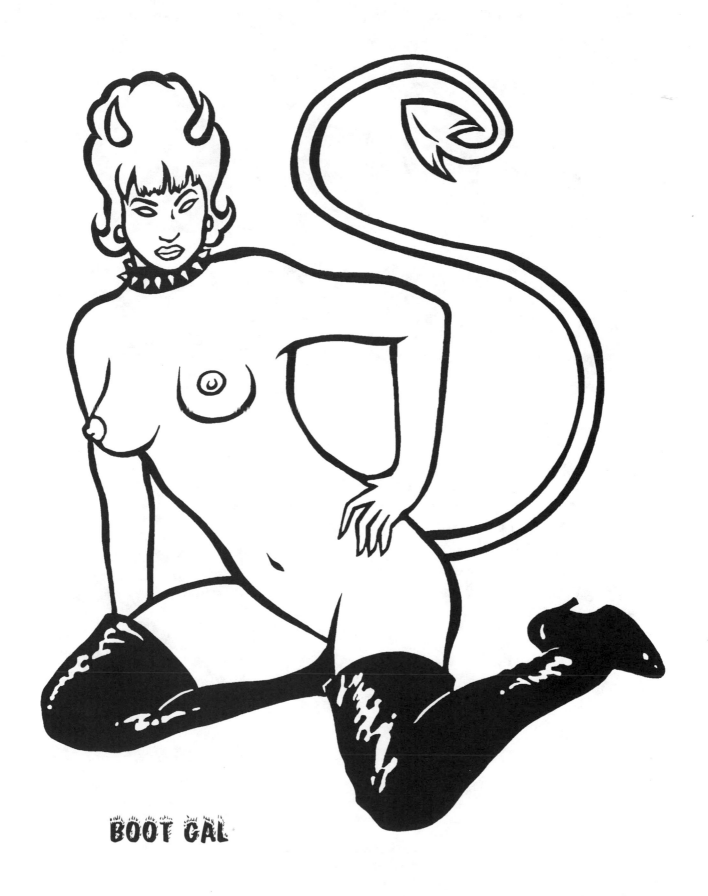

BOOT GAL

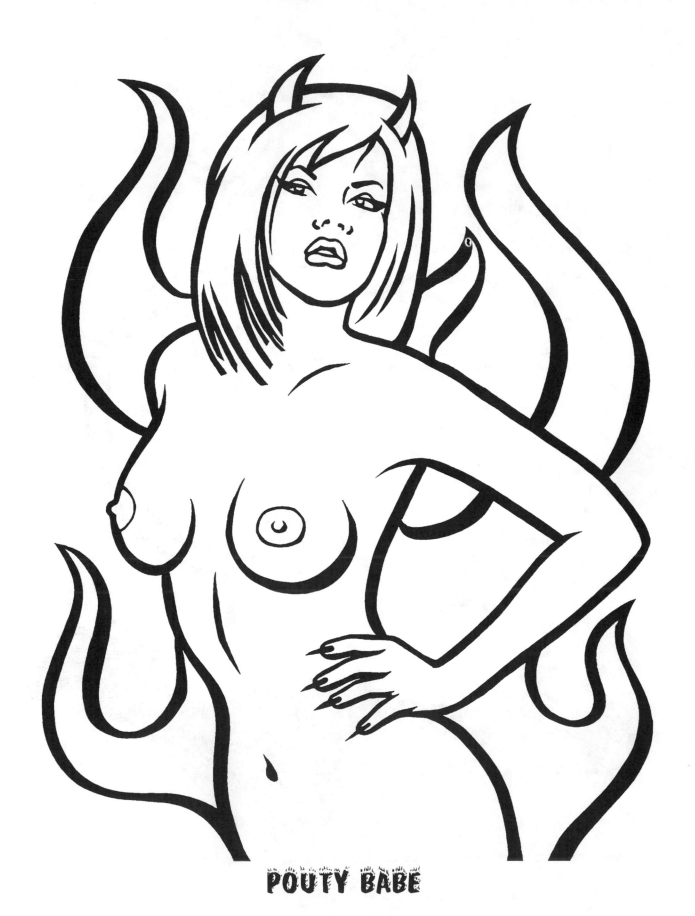

POUTY BABE

FIND THE HOT WORDS

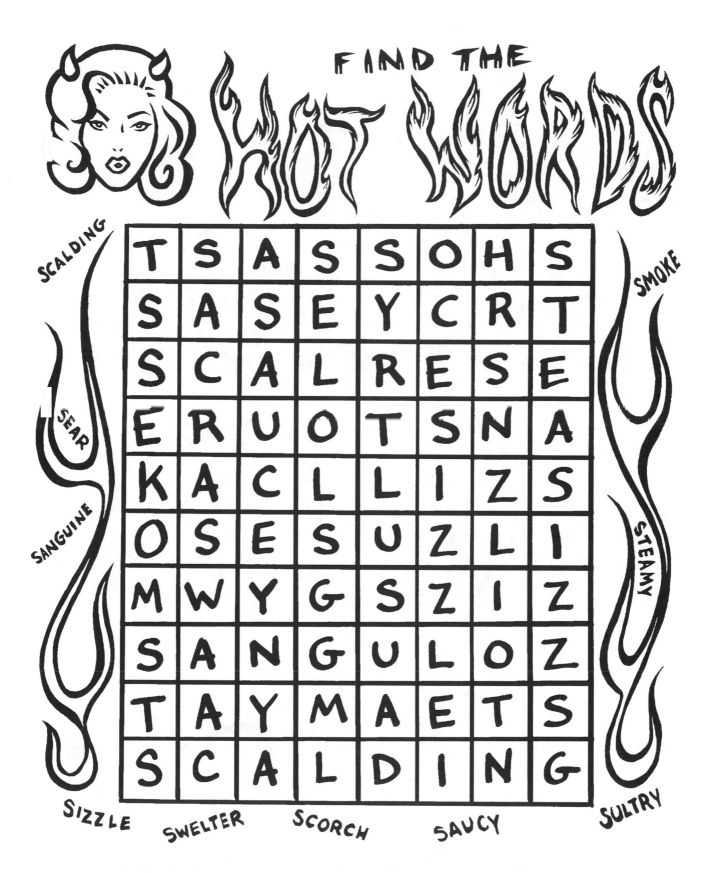

T	S	A	S	S	O	H	S
S	A	S	E	Y	C	R	T
S	C	A	L	R	E	S	E
E	R	U	O	T	S	N	A
K	A	C	L	L	I	Z	S
O	S	E	S	U	Z	L	I
M	W	Y	G	S	Z	I	Z
S	A	N	G	U	L	O	Z
T	A	Y	M	A	E	T	S
S	C	A	L	D	I	N	G

SCALDING

SMOKE

SEAR

SANGUINE

STEAMY

SIZZLE SWELTER SCORCH SAUCY SULTRY

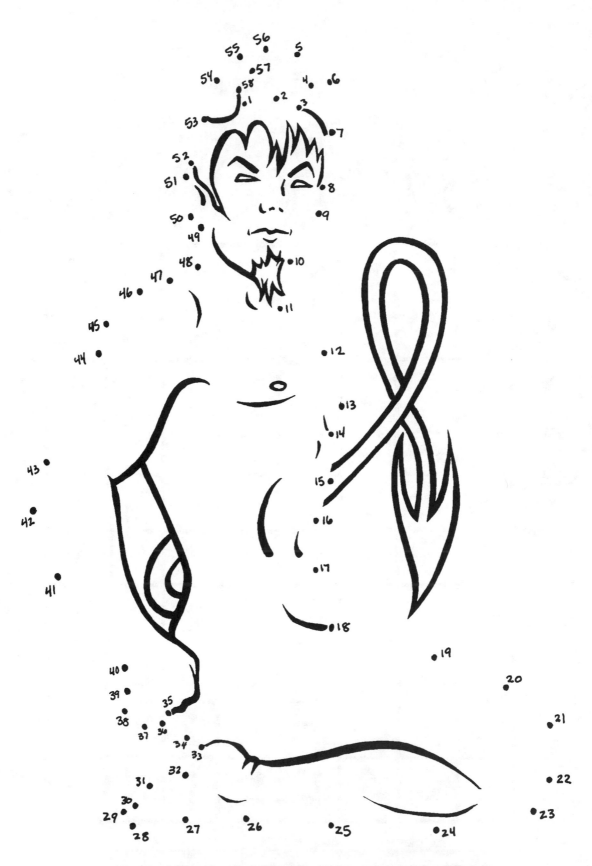

PUT THE MOVES ON MANTHING!

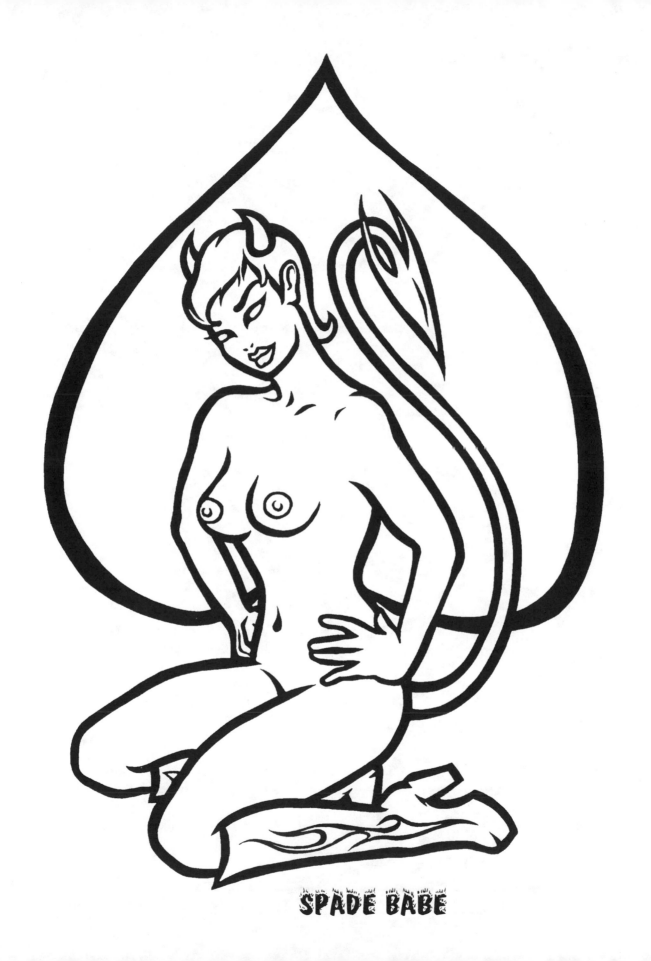

SPADE BABE

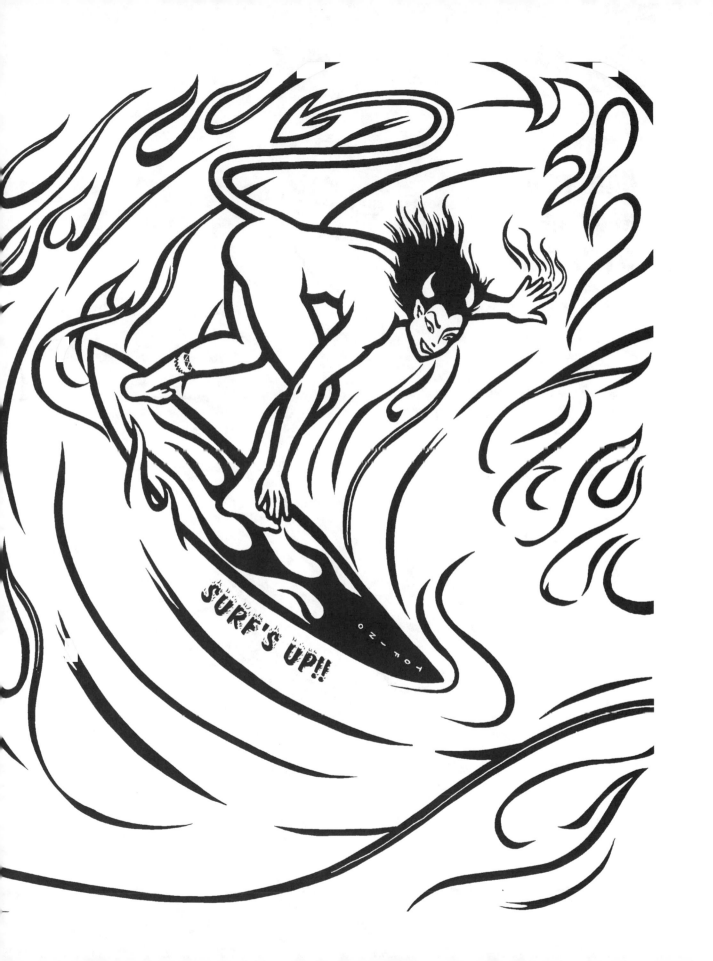

CAN YOU
HELP ME
WITH THIS
THING?

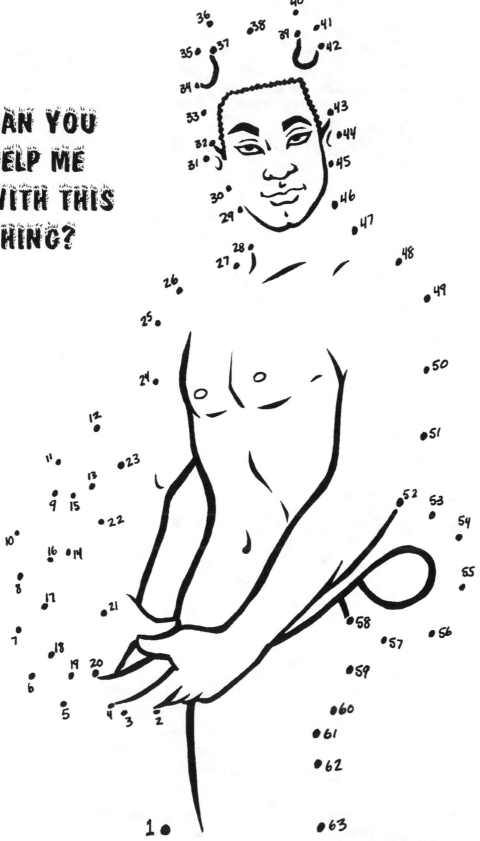

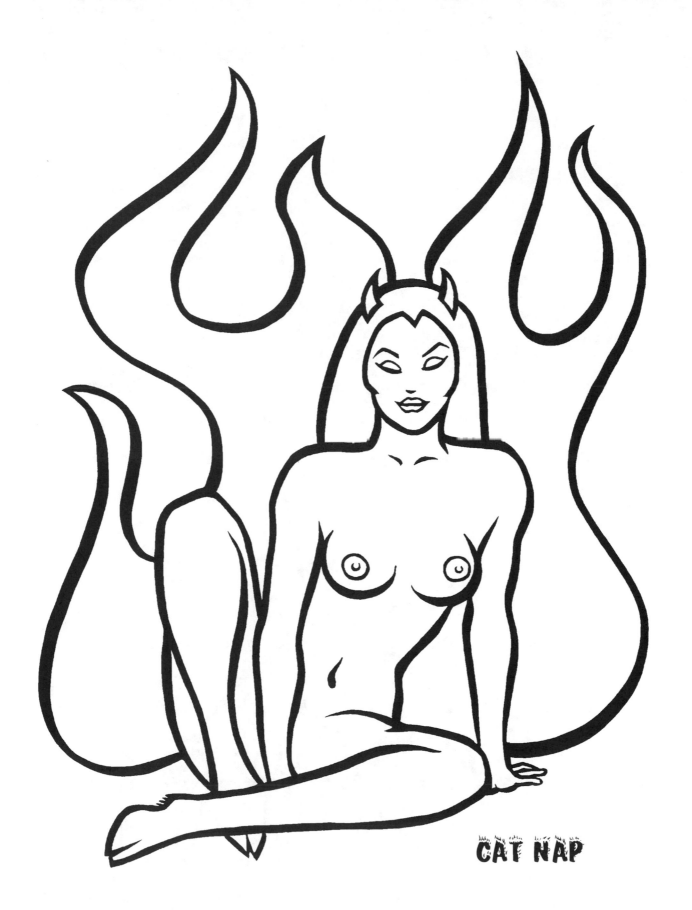

BEELZEBABE

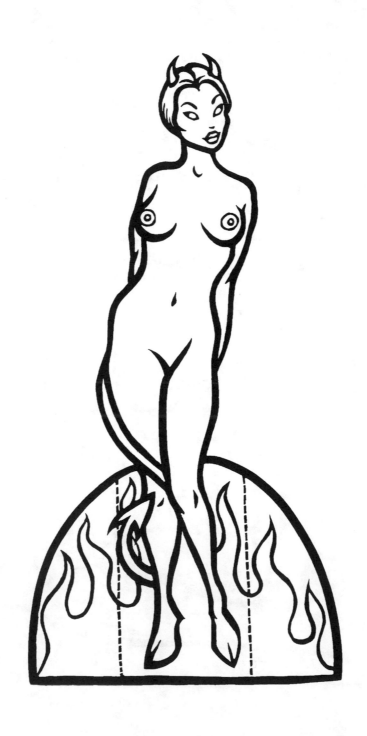

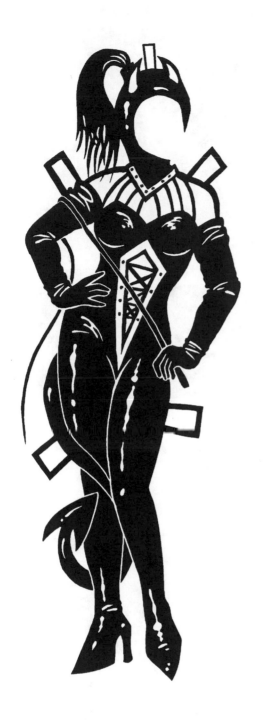

DOMINATRIX

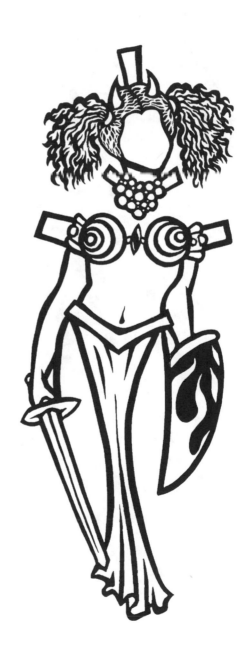

WARRIOR CHICK

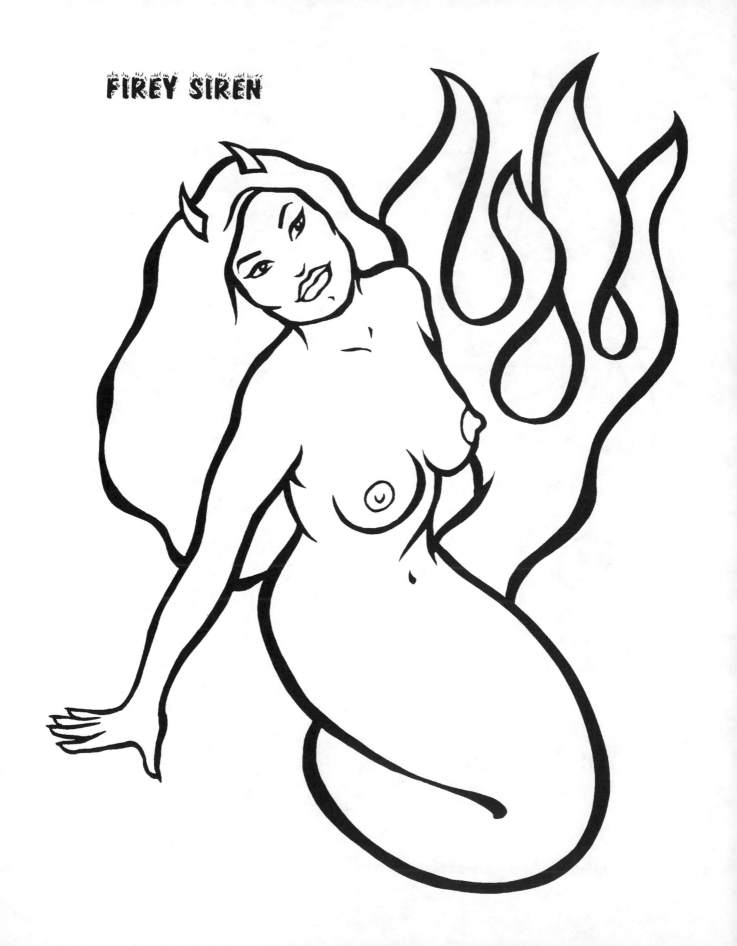

FIREY SIREN

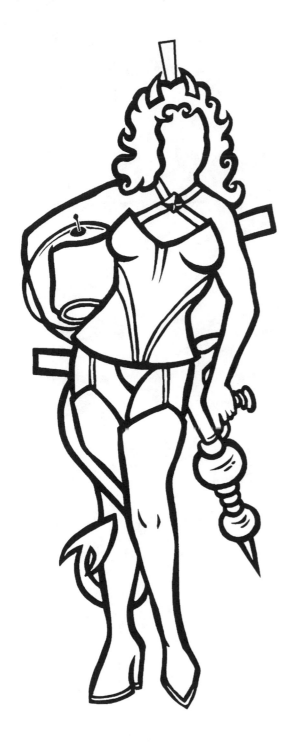

SPACE BABE

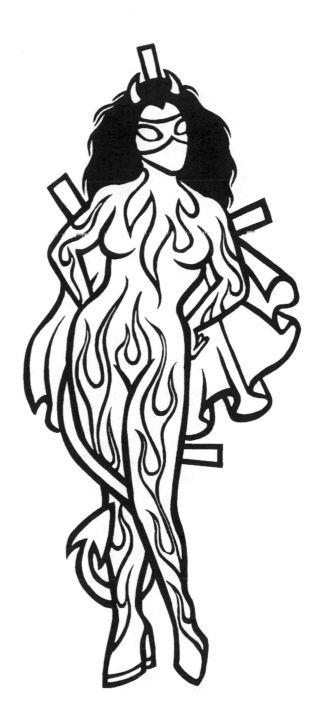

SUPER VIXEN

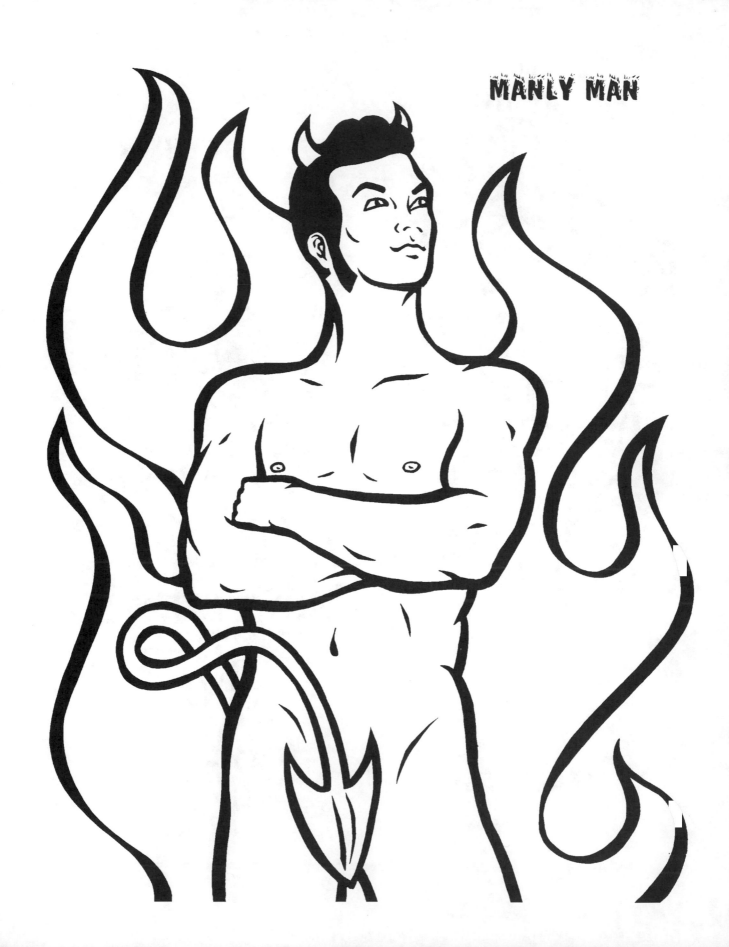

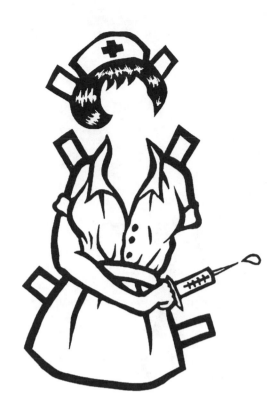

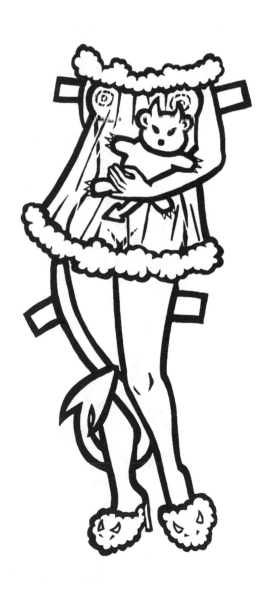

NIGHTY NITE

NAUGHTY NURSE

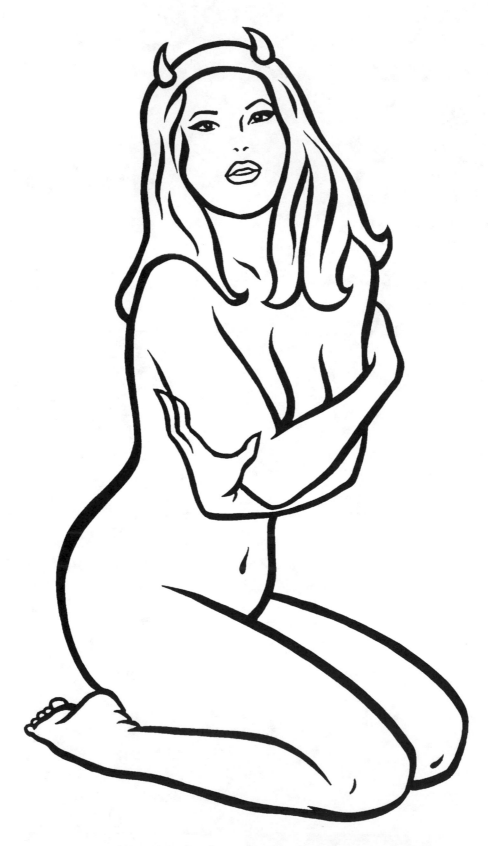

HELP DEVIL BABE WARM UP!

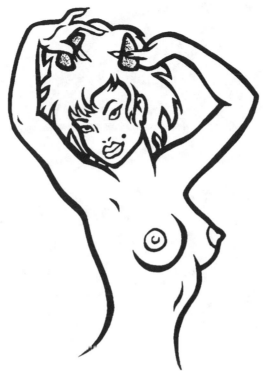

Something sweet to nibble on...

LIL' HORNS

1/2 cup butter (1 stick) at room temperature
1/2 cup + 1 tablespoon confectioners sugar, sifted
1 teaspoon vanilla
1/2 cup ground nuts (walnuts or hazelnuts or almonds)
1 cup all-purpose flour
1 cup semi-sweet chocolate chips (optional)

Preheat oven to 350. Lightly butter your baking sheets, dust with flour, and shake off the excess. Cream the butter until light and fluffy. Add sugar, vanilla, and nuts. Mix mix mix, sift in the flour and stir until everything is smooth. Roll a heaping table-spoon of dough in your hands to make a cylinder and shape into horns. (Don't make the tips too pointy or they'll get singed when you bake 'em.) Arrange on baking sheet, two inches apart, and bake for 12-14 minutes - til the edges are just getting brown.

Decadent option: Melt semi-sweet chocolate chips over very low heat (or in a double boiler) until melted. Remove from heat for a minute or two and then dip in the tips or base of the horns. Lay on wax paper til chocolate hardens.

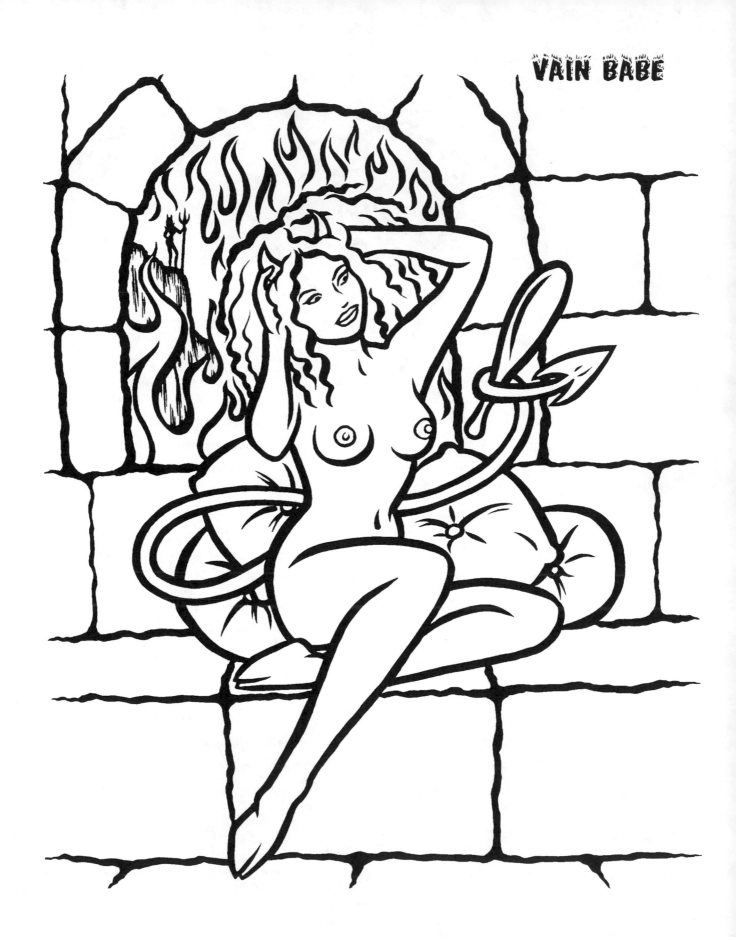

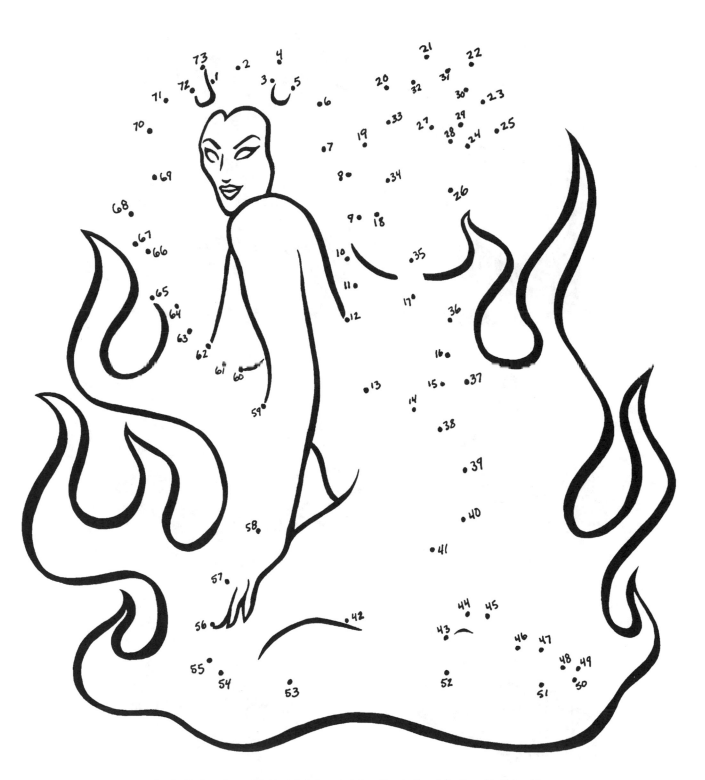

WHO'S HIDING IN THE FLAMES?

FUN WITH

Overhand Knot

Two Half Hitch Knots

Figure 8 Knot

Square Knot

Slip Knot

Lariat Loop

KNOTS!

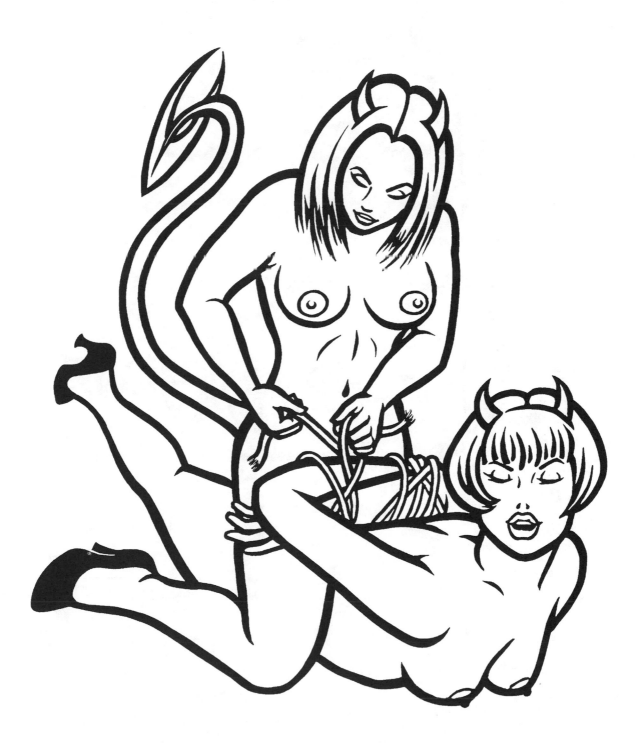

BEELZEBUBBA'S PEANUT SAUCE

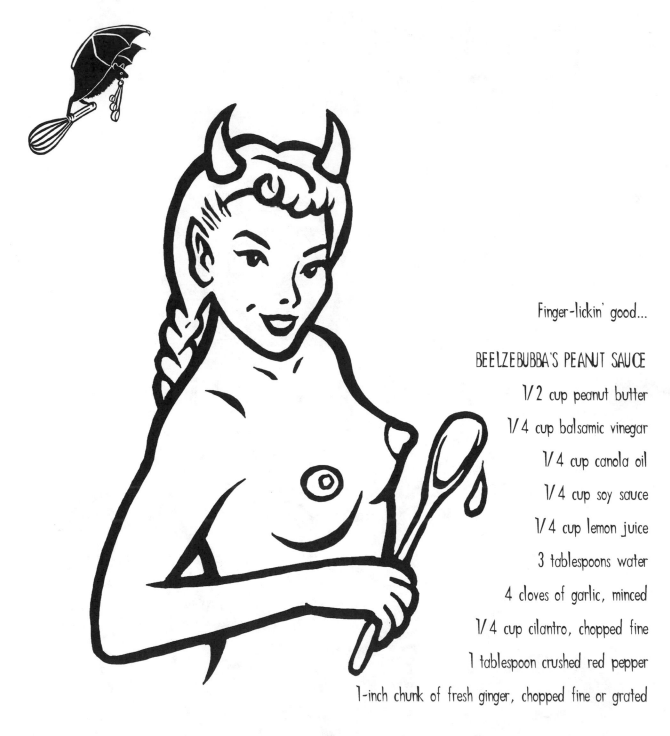

Finger-lickin' good...

BEELZEBUBBA'S PEANUT SAUCE

1/2 cup peanut butter

1/4 cup balsamic vinegar

1/4 cup canola oil

1/4 cup soy sauce

1/4 cup lemon juice

3 tablespoons water

4 cloves of garlic, minced

1/4 cup cilantro, chopped fine

1 tablespoon crushed red pepper

1-inch chunk of fresh ginger, chopped fine or grated

Combine all ingredients - if you throw them in a little blender or mixer it's instantaneous. This sauce makes everything more delicious. It's great on grilled stuff like tofu slabs and chicken kebabs, tossed with pasta (hot or cold), and over steamed or wok fried vegetables.

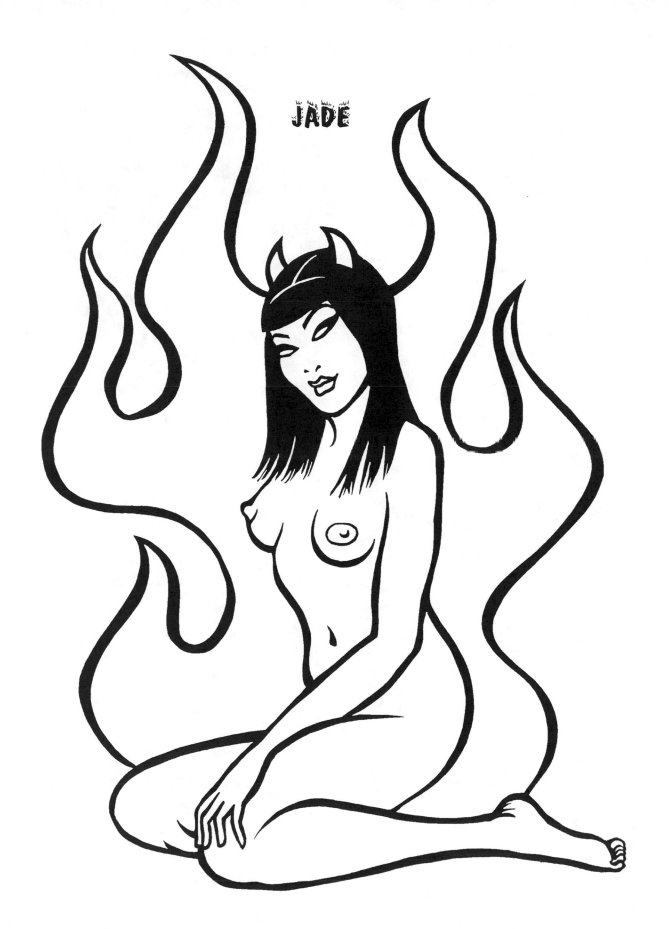

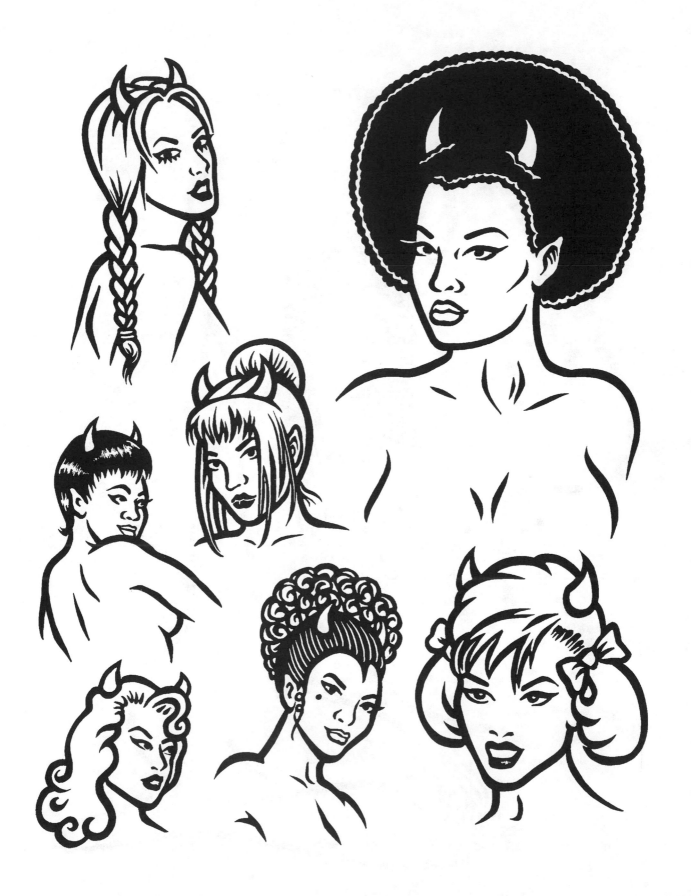

DEVIL BABE NEEDS A NEW DO!

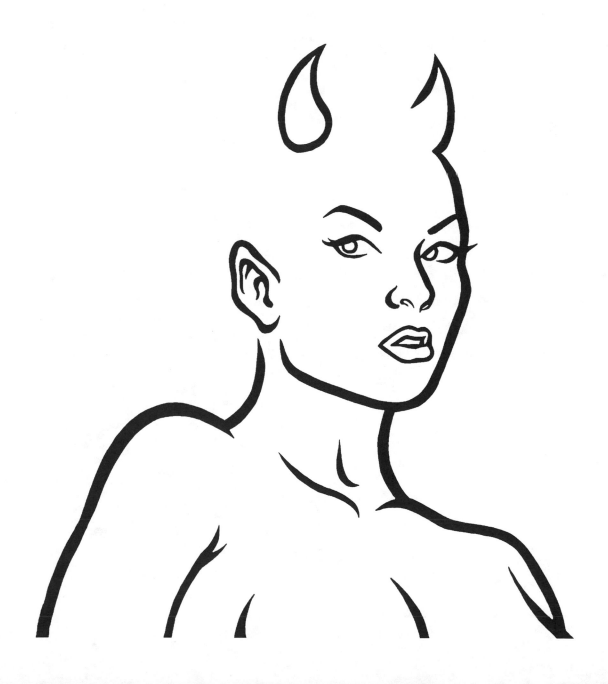

RUBY DEMON

Devil Babe has found this concoction to be only as good as the ingredients, so take the time to wash the berries and sort out any nasty ones. Splurge a little on some decent hootch, too.

RUBY DEMON
2 cups granulated sugar
2 pints raspberries
1 quart vodka

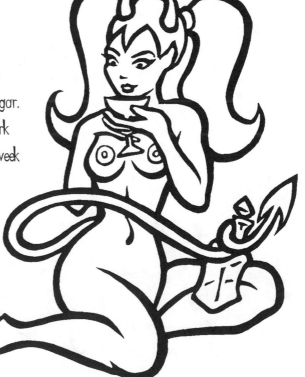

This is pretty simple – pour the vodka into a large 3-quart glass container with a lid, then add the raspberries and sugar. Screw on the cover and tuck the whole thing away in a dark place (the dungeon?). It needs a little maintenance: every week for two months you need to open it up and give it a stir.

Eight weeks later just strain it into some properly fabulous bottle of your choice and serve!

MISS BEHAVE!

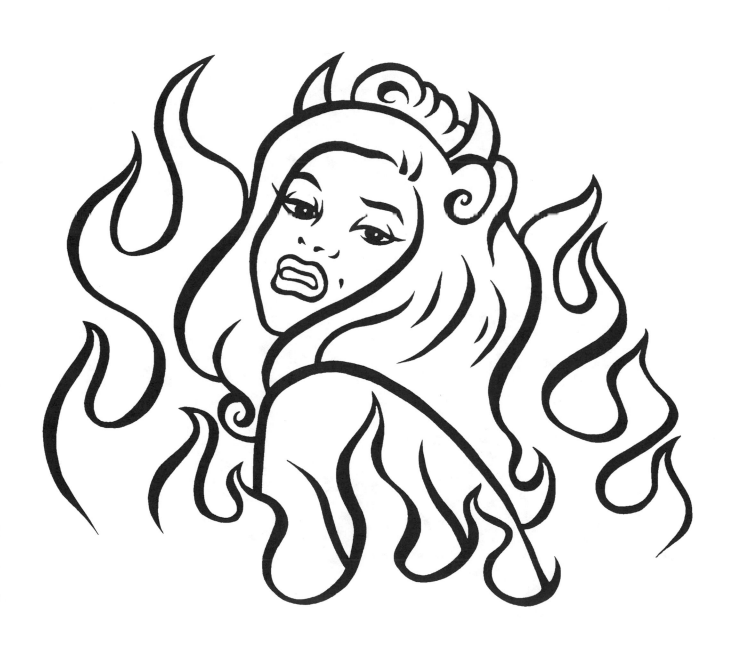

DRAW DEVIL BABE'S PET!

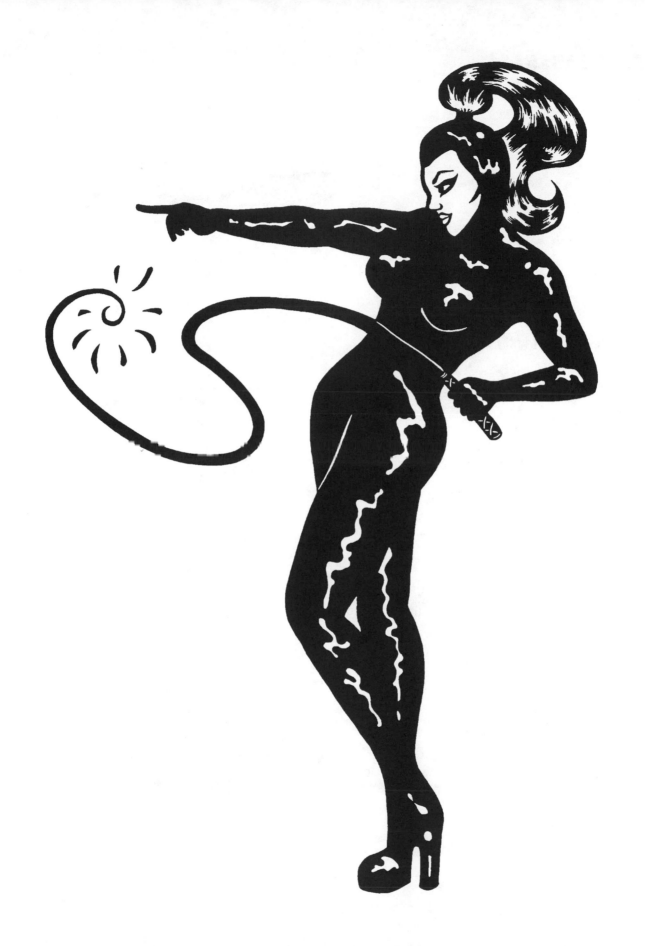

BLAZIN BANANAS

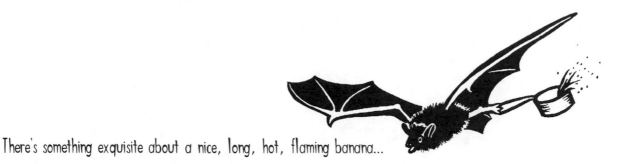

There's something exquisite about a nice, long, hot, flaming banana...

BLAZIN' BANANAS

3/4 stick unsalted butter

1/2 cup brown sugar

1 lemon's juice

5 tablespoons orange liqueur

6 bananas, sliced lengthwise

5 tablespoons rum

Heat a skillet over medium high heat and melt the butter til it's bubbling (careful not to burn it). Stir in the brown sugar and lemon juice. Stir stir stir, adding the orange liqueur. When it's bubbling, lay the bananas in there. Baste them with the sauce. Keep cooking and basting until the liquid thickens up, about five minutes.

Nobody likes a totally limp banana so try not to overcook them.

Now for the fun part:
Pour in the rum and ignite it with a match (watch your eyebrows).
Spoon the flaming liquid over the bananas until the flames die down.
Serve 'em up!

WORK THAT THANG!

MERBABE

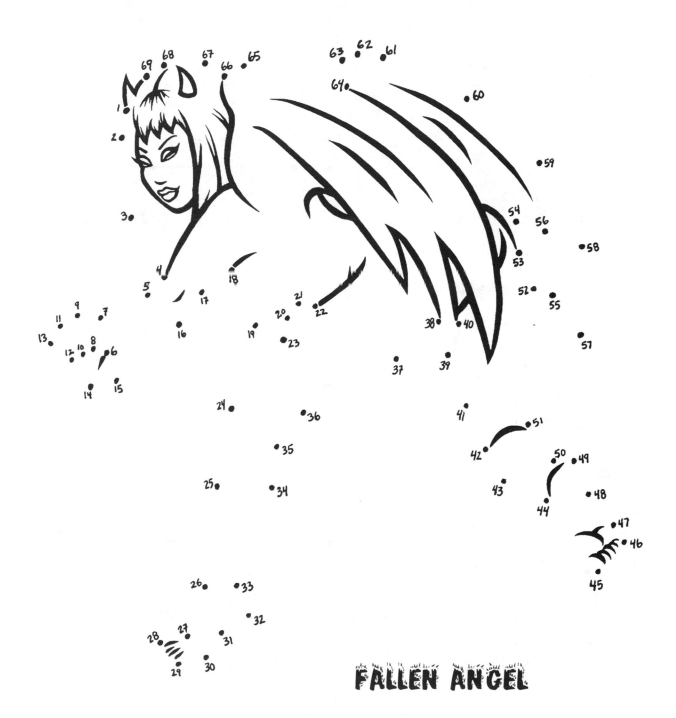

FALLEN ANGEL

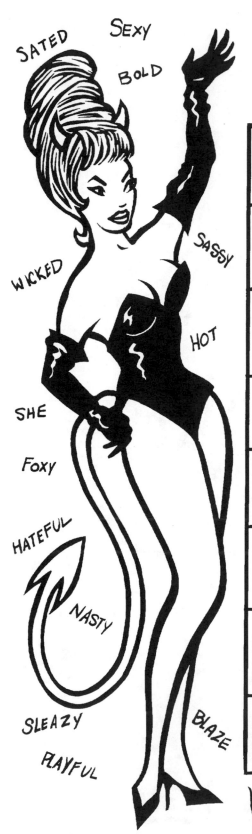

SATED SEXY BOLD
WICKED SASSY HOT
SHE FOXY
HATEFUL NASTY
SLEAZY BLAZE
PLAYFUL

FIND 13 DEVILISH WORDS

D	E	K	C	I	W	A
P	B	D	L	O	B	H
L	L	Y	T	S	A	N
A	A	D	E	T	A	S
Y	Z	A	E	L	S	A
F	E	F	S	E	H	S
U	U	Y	X	O	F	S
L	O	Y	T	A	B	Y

LOOK UP, DOWN, FORWARD, BACKWARD AND DIAGONALLY

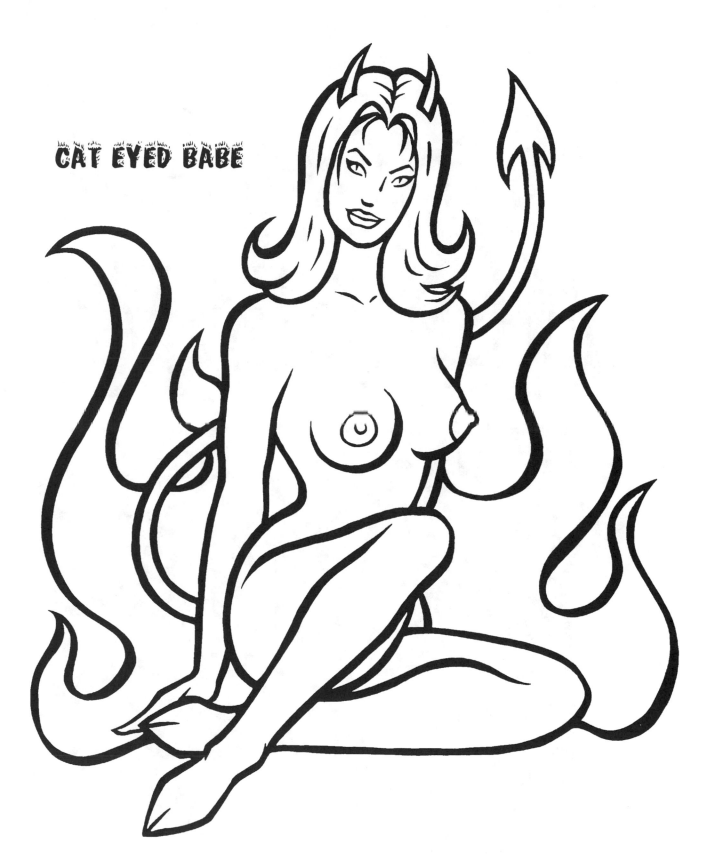

CAT EYED BABE

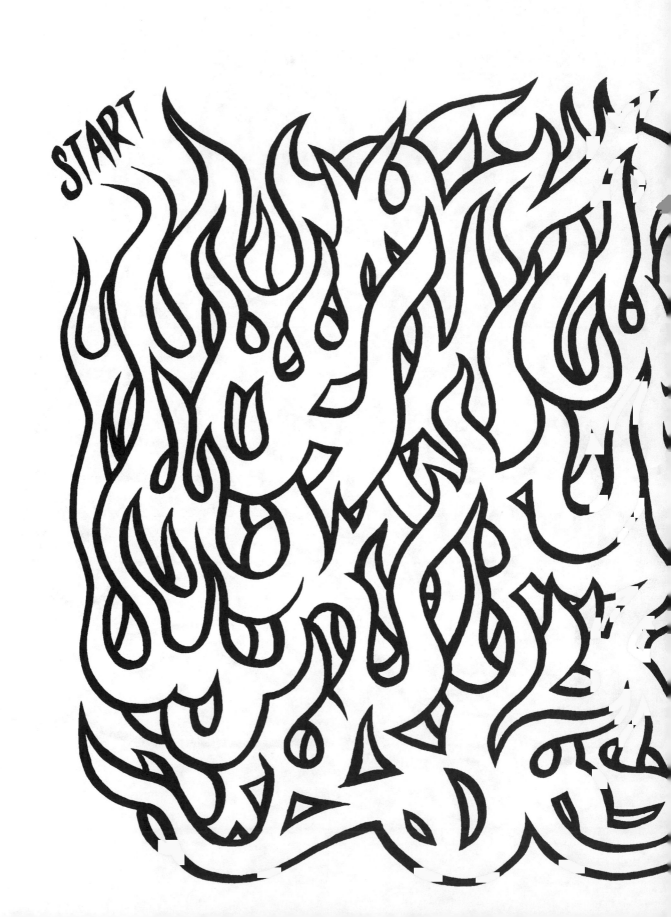

LOUNGIN' BABE

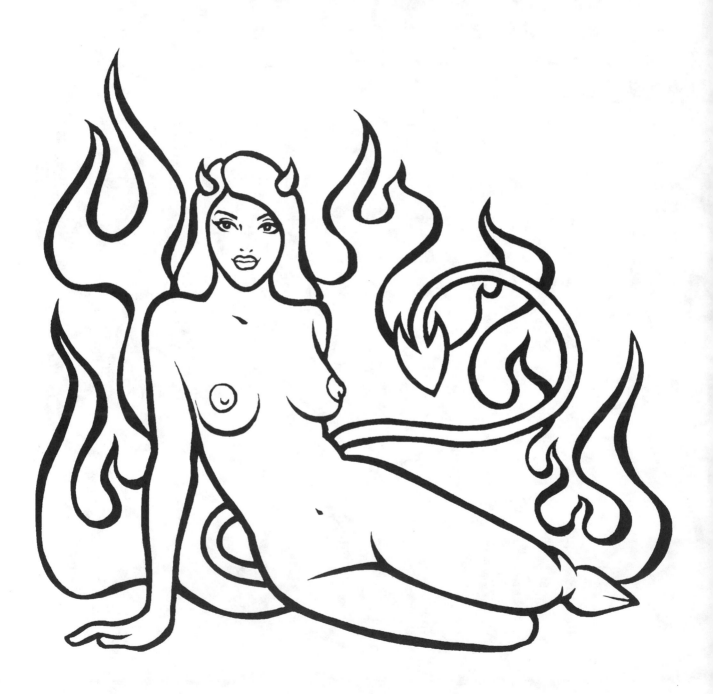

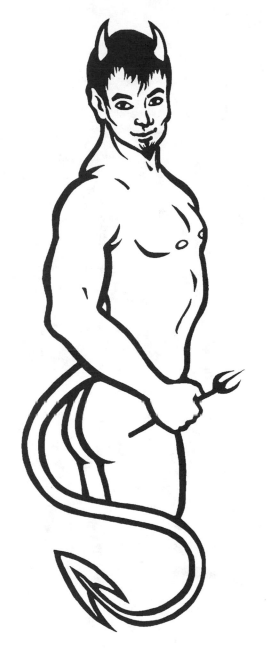

Devil Dude loves cocktail parties, and
a party is not a party without assorted yummy tidbits...

X-TRA SPICY DEVILED EGGS
6 eggs
3 tablespoons mayonnaise
1 teaspoon mustard
salt
black pepper
garlic powder
onion powder
paprika
Tabasco sauce
cayenne

Put the eggs in a pot and cover with water. Bring to a boil, and cook for 15 minutes. Remove the eggs from the hot water and place in a bowl filled with ice water. This ensures that they will peel easily - these eggs have got to look good! Slice each egg in half lengthwise and remove the yolk. Put the yolks in a bowl and mash them with a fork, add the mayo and mustard. Add a sprinkle of salt, pepper, garlic powder, onion powder, and paprika, and mash some more. Add 2 dashes of Tabasco sauce and mash. Add a pinch of cayenne. Mash. Taste. Add more cayenne and Tabasco if necessary. Mash until smooth and creamy. Make a pastry tube by rolling a piece of wax-paper into a funnel, spoon the yolk mishmash inside, and pipe it back into the egg whites. Garnish with fresh chopped parsley or a light sprinkling of paprika.

CLIFF BABE

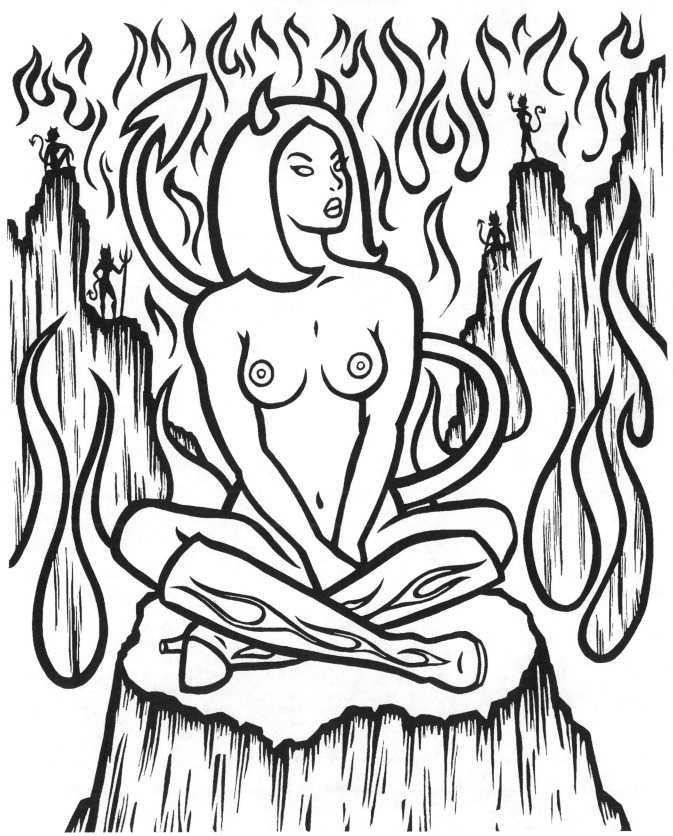

BOUFFANT BABE

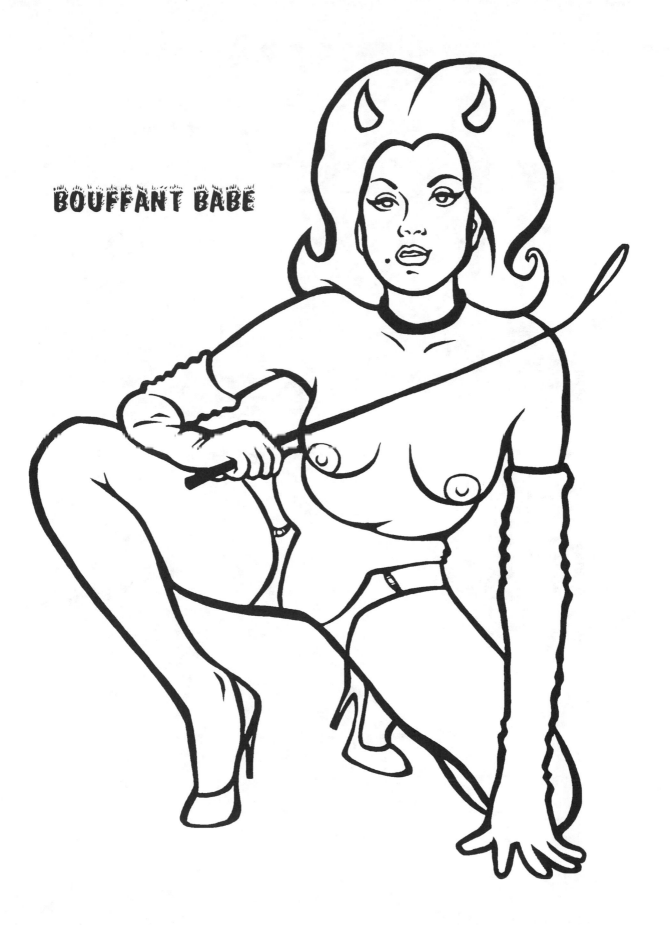

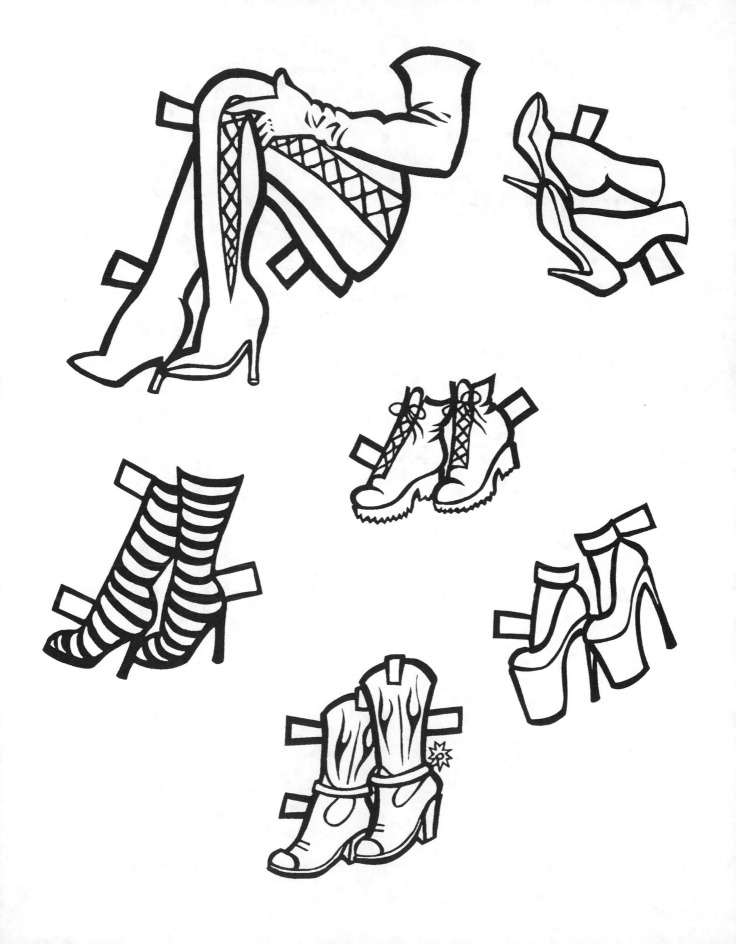

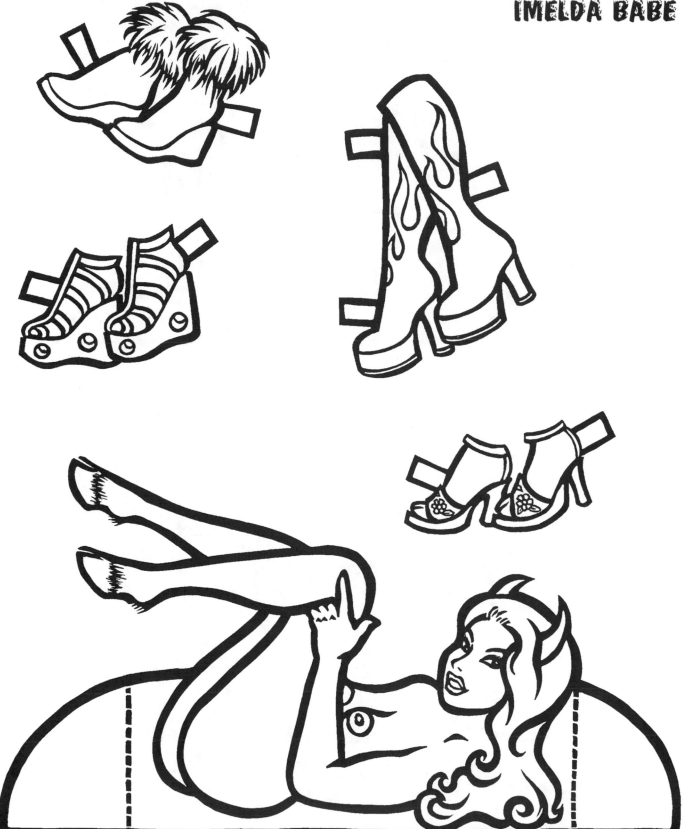

IMELDA BABE

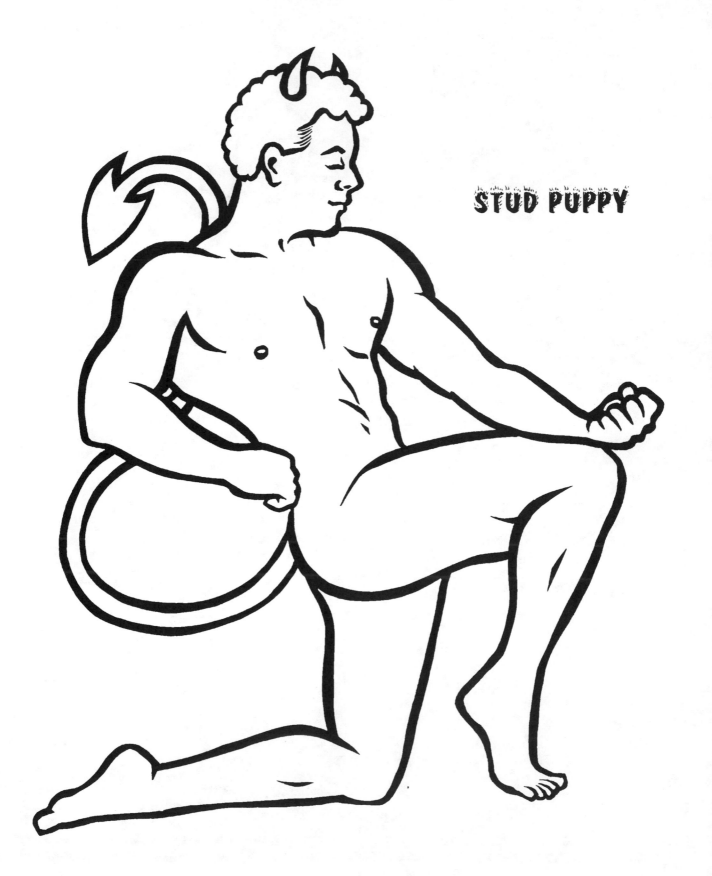

STUD PUPPY

HOT NUTS

4 cups unsalted dry roasted peanuts

1/8 cup melted butter

1 tablespoon red pepper flakes

1/2 tablespoon chili powder

1 teaspoon salt

Pour the peanuts out onto a pan — any roomy pan will do: pizza pan, cookie pan, etc. Mix up the melted butter, pepper flakes, chili powder, and salt, and drizzle over the nuts. Oh hell, just pour it on. Toss 'em around so everything is covered.

Bake at 350 for 15 minutes but get in there and stir the nuts around every few minutes or so (you want Hot Nuts, not burned, blackened, inedible nuts).

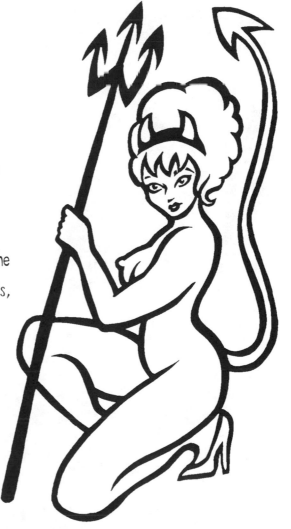

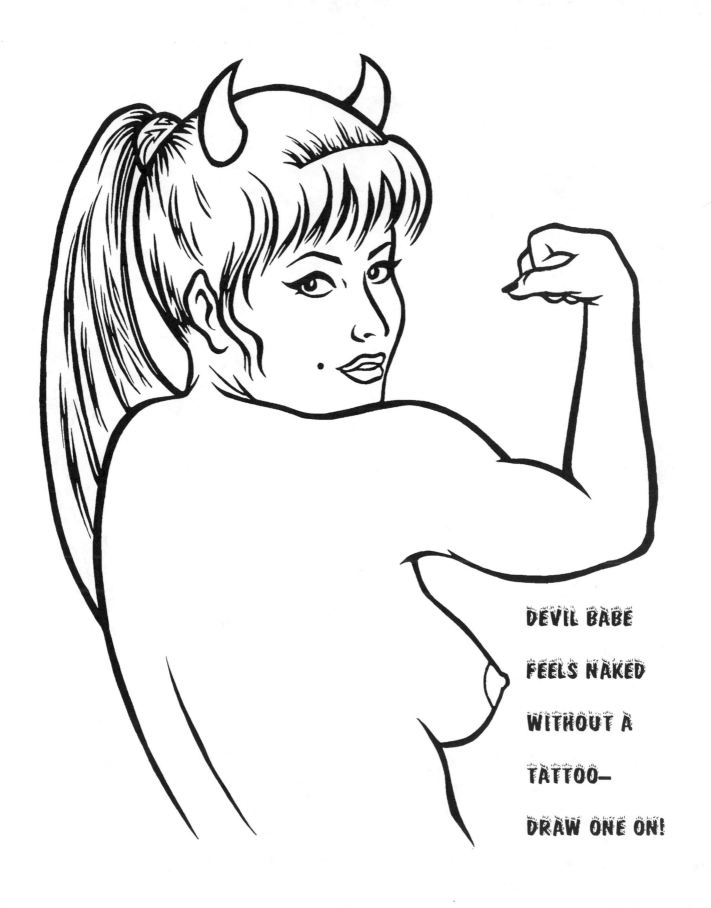

DEVIL BABE
FEELS NAKED
WITHOUT A
TATTOO—
DRAW ONE ON!

How Many Words Can You Make Out Of

DEVIL BABE

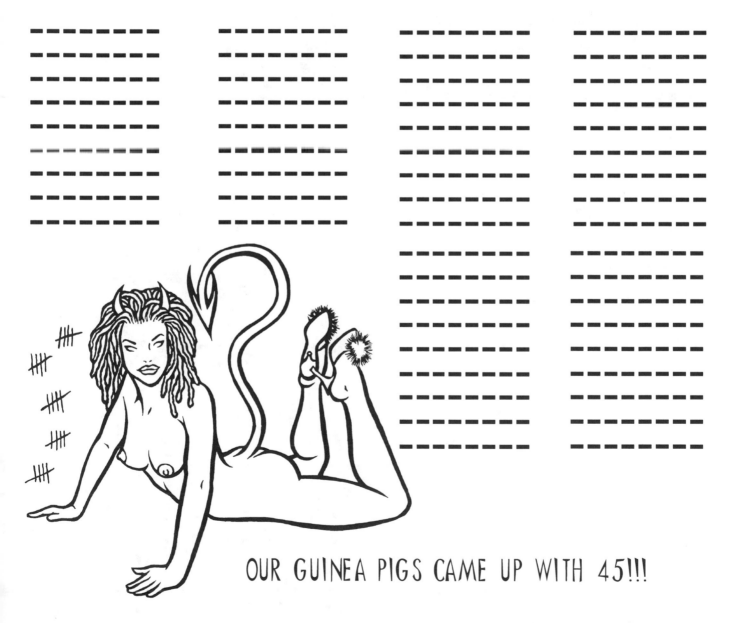

OUR GUINEA PIGS CAME UP WITH 45!!!

INFERNALLY HOT PASTA SAUCE

This will really only work if you've got the time to let it simmer. We're talking hours here.

INFERNALLY HOT PASTA SAUCE
1 large can (28 oz.) crushed tomatoes in puree
1/2 medium yellow onion, chopped fine
1/2 teaspoon crushed red peppers (hot red pepper flakes)
1 stalk of celery, minced all to hell
4 tablespoons sweet butter
1 habenero or jalapeno pepper, minced microscopically fine*
Salt & pepper to taste
4 tablespoons vodka

Saute onion and crushed red peppers in butter just until starting to become translucent. Pour in all other ingredients except vodka! Don't add that yet! Cook the sauce over a microscopic flame for a good couple of hours. (Go do some word scrambles, color in a few drawings...)

When the sauce has been simmering for several hours, get your pasta cooking. When it's just tender (al dente, si?) drain it, shake it out well, toss it in with the sauce and let it sit there for a minute or two to soak the sauce up. Then pour your pasta a drink – mix in the vodka, toss and serve.

Good for about 1 lb. of pasta, serves four.

* A Note On Heat: Devil Babe finds jalapenos readily digestible. The habenero pepper is for the person who wants to eat dinner and experience the flames of Hell simultaneously.

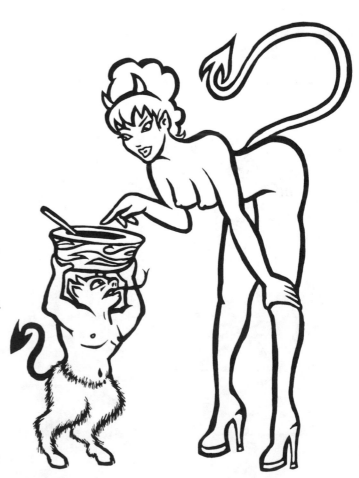

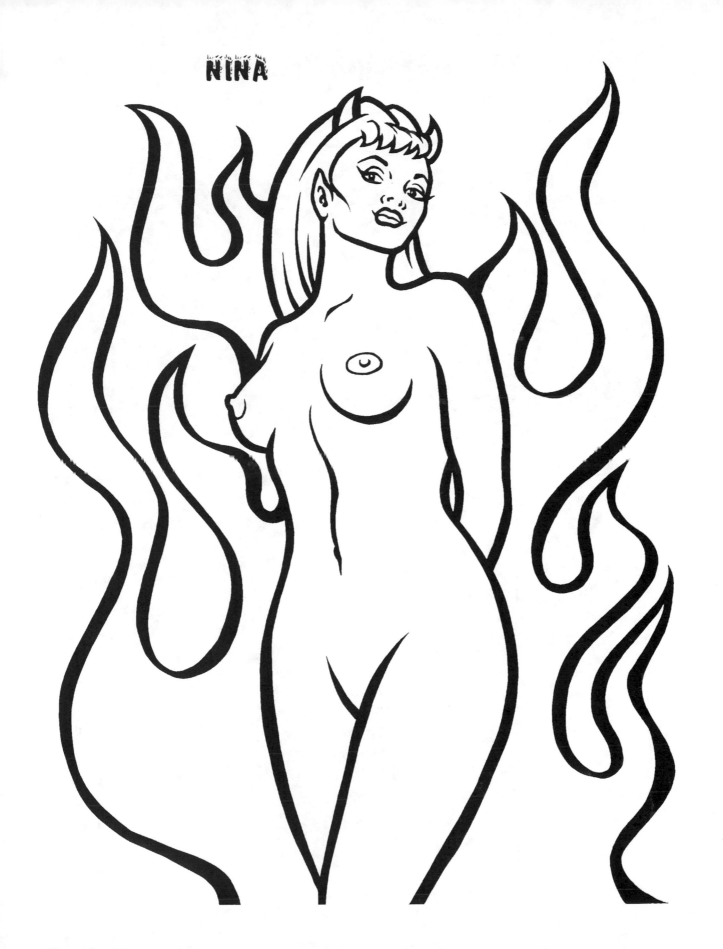

AN A-MAZE-ING HAIR DAY!

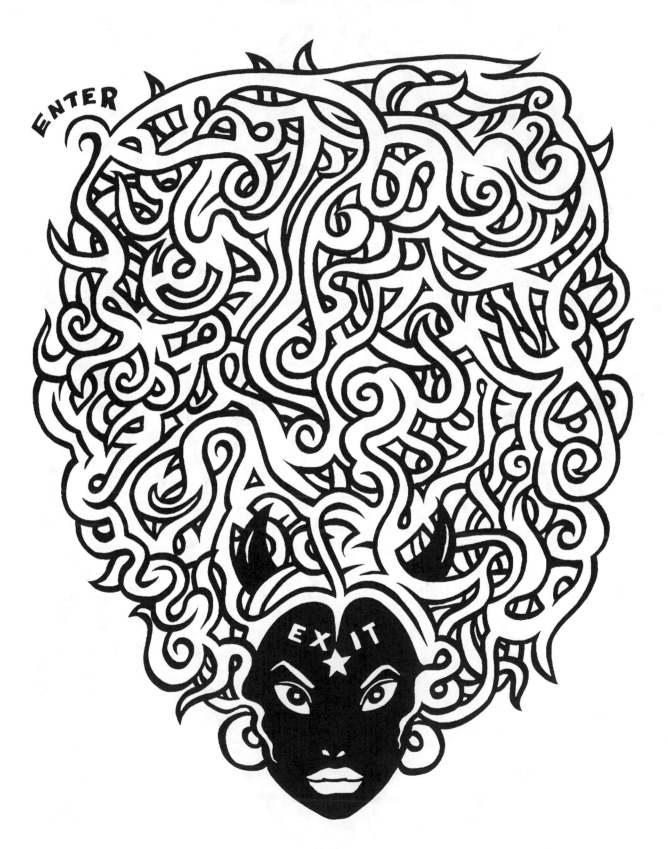

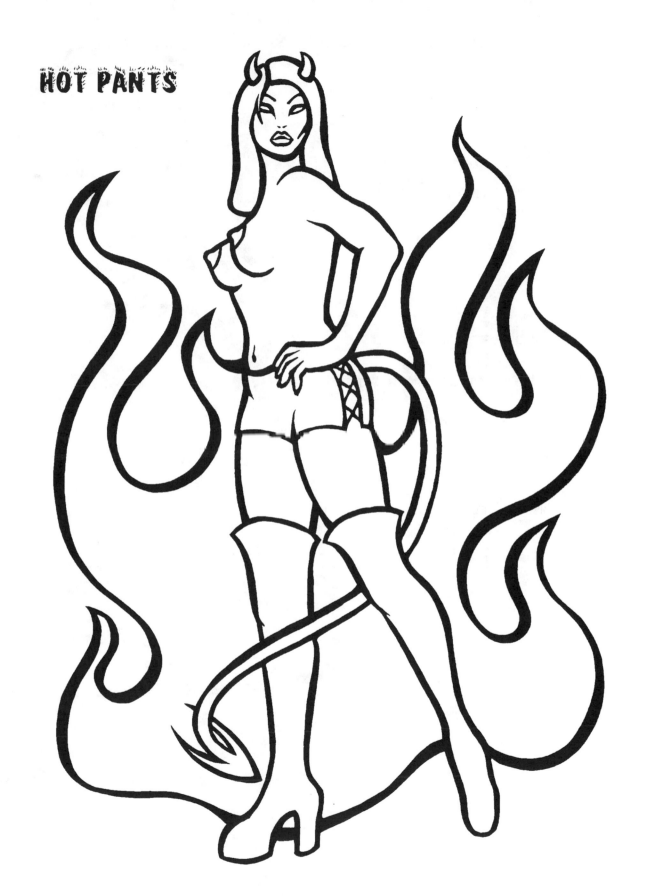

HOT PANTS

PEACHES N' CREME

Spread it on and lick it off....

8 oz. cream cheese

2 tablespoons milk

2 tablespoons confectioners sugar

1/4 cup chopped peaches

Blend all ingredients

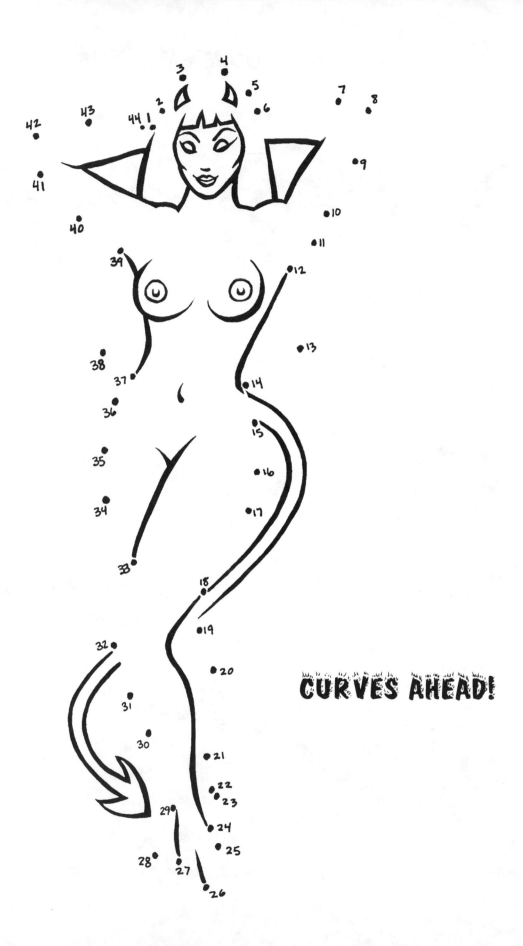

CURVES AHEAD!

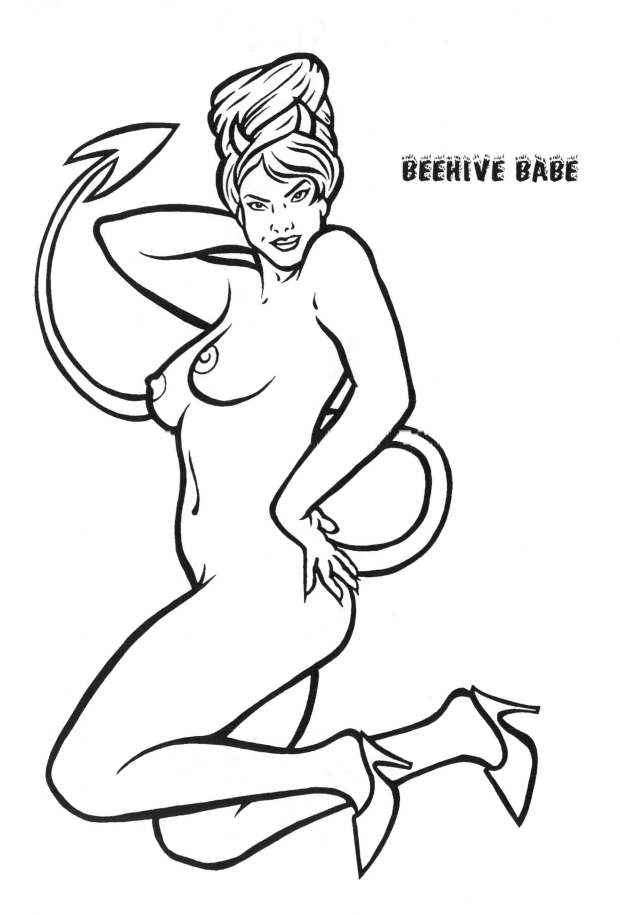

BEEHIVE BABE

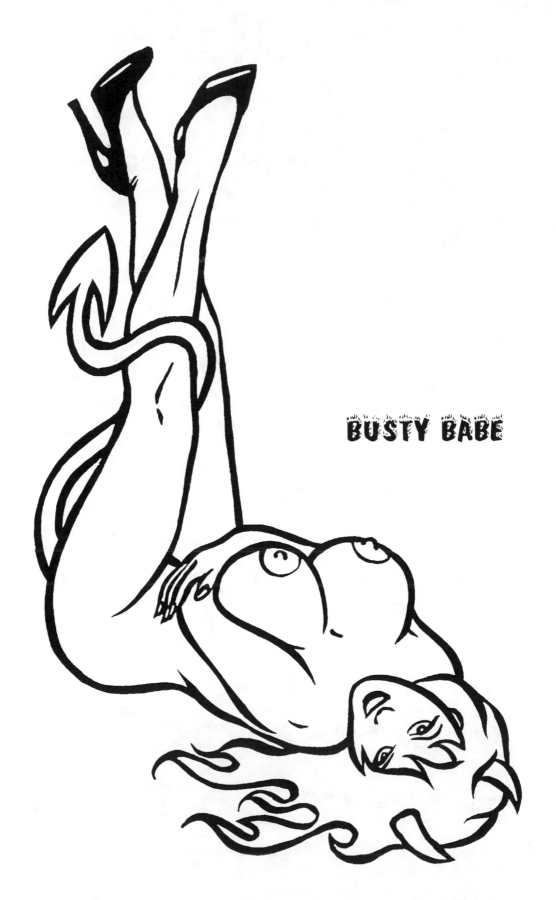

BUSTY BABE

You knew it had to be in here somewhere. The truth is that Devil Babe usually buys a mix, preferring to spend her time making frosting and decorating the cake. But we know several hellish cooks who wouldn't be caught dead with a box of cake mix in their cabinets, so for them we suggest this recipe.

ULTRA-CHOCOLATE DEVIL'S FOOD CAKE

1 cup sifted flour
1 teaspoon baking powder
1/4 teaspoon baking soda
Dash of salt
1/4 cup plus one tablespoon cocoa
3/4 cup sugar
1/4 cup plus 1 tablespoon unsalted butter
1/2 cup milk
1 egg
1/2 teaspoon vanilla extract
1/2 cup chocolate chips, crushed

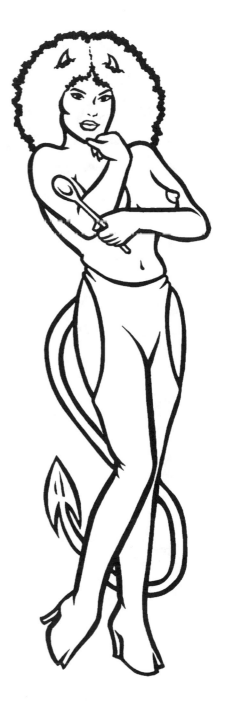

Preheat oven to 350 degrees. Sift together flour, baking powder, baking soda, salt, cocoa, and sugar. Add the butter, milk, egg, and vanilla, and blend with electric mixer on very low speed until the ingredients are moistened. Mix three minutes on medium speed, scraping the sides of the bowl often to make sure everything's getting blended. Mix in the crushed chocolate chips. (You can crush them in a blender, mini food processor, or put them in a plastic bag and stomp on them in your favorite platform shoes!) Pour the batter into a buttered nine-inch cake pan. Bake for approximately 30 minutes.

Devil Babe strongly recommends wearing an apron as she almost wrecked her favorite sweater when the electric mixer kicked in. This batter requires a lot of mixing and is ever so much easier with a little electric beater. If you don't have one of those and your arms aren't up to the task, invite someone over who you'd like to watch flex over a bowl of batter.

CAN YOU DRAW
A DEVILISH VALENTINE?

What you put it on is your business!

DELICIOUSLY DEMENTED FROSTING

2 egg whites

1/4 teaspoon cream of tartar

1/3 cup cold water

Dash of salt

1 1/2 cups sugar

1 teaspoon vanilla

(This recipe requires a double-boiler. If you don't have one, fake it with two pans: the bottom one filled with water, the other floating/resting on top.)

Fill the bottom of a double boiler with water and heat to boiling over medium heat. Before you put the top of the double boiler on, put all the ingredients except the vanilla into the top pan and beat for one minute with an electric mixer (Don't have one? Try to beat the living hell out of it by hand).

Now put it over the already boiling water and keep beating, beat beat beat until the mixture loses its gloss and forms peaks that hold their shape —should be exactly seven minutes. Remove from heat. Add the vanilla and beat until it's all mixed in.

Spread on willing subject/object immediately, as the frosting will begin to form a delicate crust as soon as it starts to cool. Demon Chef Jayel instructs, "Frosted objects (Devil's Food Cake is classic but feel free to experiment) should be allowed to breathe, i.e., do not seal in Tupperware, shrink wrap, etc. as frosting will become sticky."

Enough to cover two round layer cakes, or a fairly expansive stretch of exposed flesh.

FLAMING ZOMBIE

Light up the night and wake up the dead!

FLAMING ZOMBIE
1 1/2 oz. dark rum
1/2 oz. Jamaican rum
1/2 oz. light rum
1 oz. lime juice (fresh!)
3/4 oz. pineapple juice
1/2 oz. orange juice
1 oz. 151 proof rum

Mix all ingredients except for that last shot of high octane rum in a shaker with ice. Pour into glass then "float" the 151 proof on top by pouring it over the back of a spoon that's resting on the surface of the drink. (You can do this, honest.) Now turn the lights down low and light the rum float with a long fireplace match (you'll be glad you used it when you still have your eyebrows tomorrow). Sometimes the flames are nearly invisible so make sure you blow them all out before you take a sip!

KALI BABE

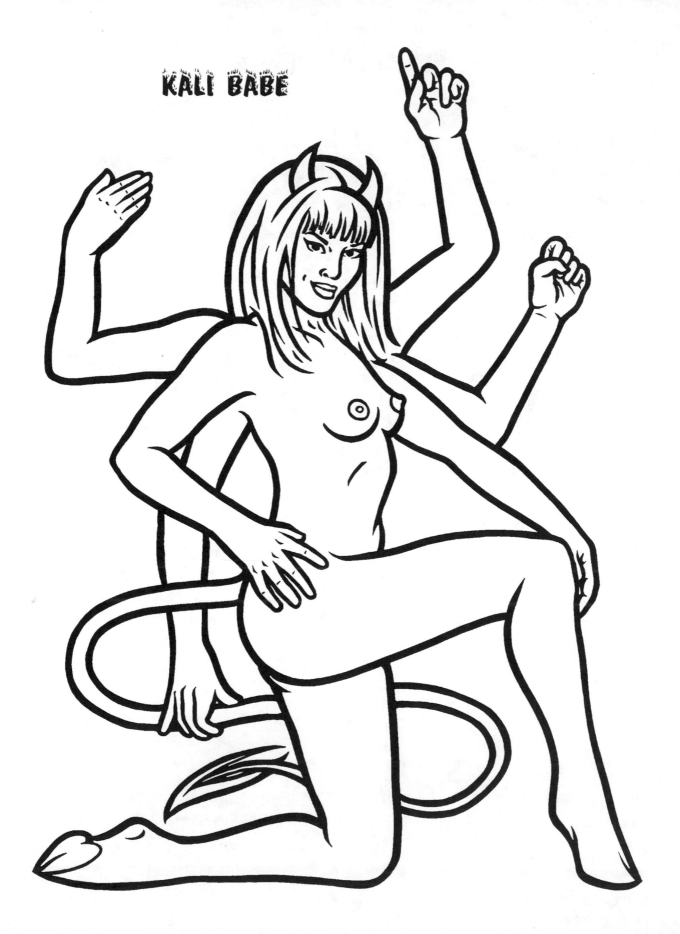